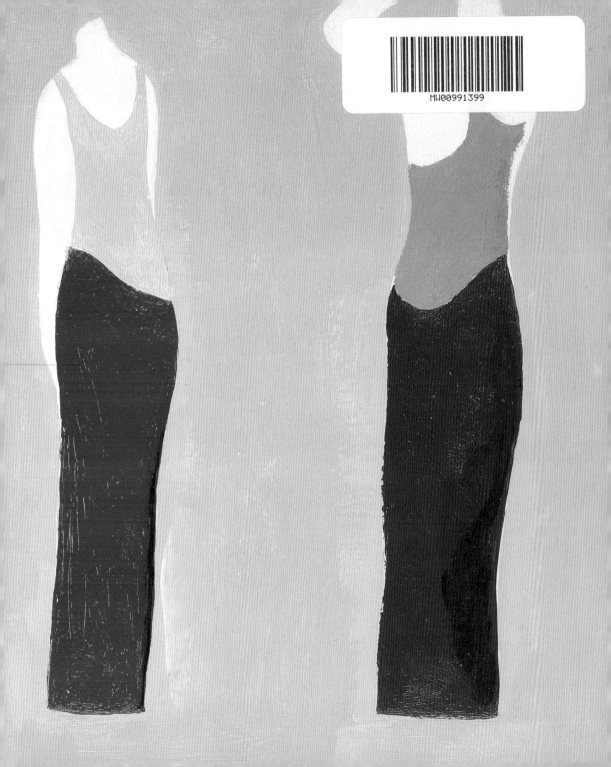

What is beauty? As children, we feel this question ripening inside fairy tales, those brambled landscapes home to strange symbols and spellbound creatures. Stand back a bit, study the spells, and you begin to see that most fairy tales are simply about seeing. They are journeys, quests for a beauty beyond the conventional surfaces and symmetries. As all artists know, you cannot decide what is beautiful if you do not look carefully and continuously at the world around you. This book is a journey with Geoffrey Beene, the fashion designer who has never stopped seeing.

 To enter into the province of Beene is to enter a time and space that is uniquely apart, a place both magical and modern. Beene works with the actual materials of folk- and fairy tales, with humble cottons and castle laces and garden-fresh French silks. But he also feels the enchantment of our era's high-tech stretch fabrics – wool jersey of such airy ease it wants to fly. Velvet is too gloomy for Beene's millennial kingdom, but may enter if it's *panne*, spun from silk into mercuric silver and molten gold. In Beene's hands, you see, materials begin to breathe and move.

 And dance and leap. Indeed, Beene is legendary for the life force flowing in his work, an energy that leads into the future, not back into a sachet past. You feel a kinetic pull, an organic sense of shape in his design, his seams growing like tendrils, curving, lifting toward the sun, his silhouettes guarding their mystery like moon-blossoming flowers, his geometries a puzzle for Euclid or young Mozart (is that a triangle or a comet-tail? and where did it originate?). Perhaps this is why Beene has an almost childlike love of the color orange – it is the plump pumpkin become an enchanted carriage, stillness become speed, a Halloween of transformations.

You may recall that the word "legend" has a second definition – it is a key to the symbols and colors on a map. Obviously, Beene has given us many keys to the female body. He uses seams, slashes, and net insets to point up the horizons of the hip, the dawn of the lower back, the interplanetary curve under the ribs. And yet the geography of the body is not all he reveals.

Through his eyes, we also see our cities, our country, our time. Keenly attuned to art, film, and dance, Beene travels widely to see new buildings, new theater, new orchids just opened. He is drawn as much to the delights of Culture as he is to the strangeness of Nature: both offer parables of creation. Both play deep within Beene's design. This is why it is possible for us to travel through his work – like Alice through the looking glass or Dorothy in Oz – and see the world at new angles. To the question "what is beautiful?" Beene finds design answers that also have meaning in life, that feel like the moral of a story. We must use what is at hand, he seems to say, we must go forward with hope. There are still so many roads, or seams, not taken, and a step into the unknown does make a difference. In Beene, we see that fashion design can be poetic expression of the highest order.

At the end of this journey we come to a blue sky and a white flutter that might be doves, angels, an annunciation – a spell or a farewell. In fact, we are looking at a pair of gloves designed by Geoffrey Beene. "The hand implies humanity," says Beene, "it's all about gesture. Decorate that gesture and it becomes more powerful." What Beene says about gloves may be said of his art. It is the decorated gesture, the light touch which is a touch of light.

How do you make a perfect curve? "More than anything," says Beene, "it takes time."

Have you observed the circles you're inside? We lift our heads out of round collars, reach through circular sleeves and armholes like hours. A hem halos every step.

Your eye receives light through a circle.

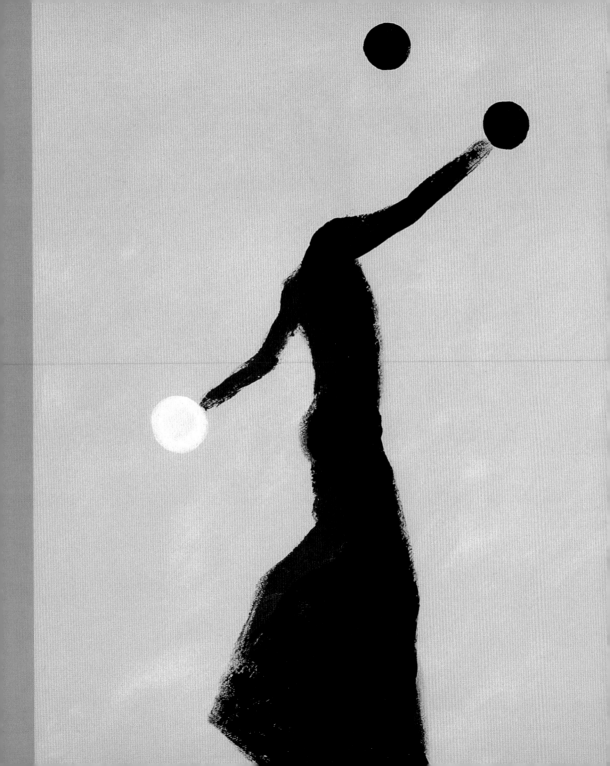

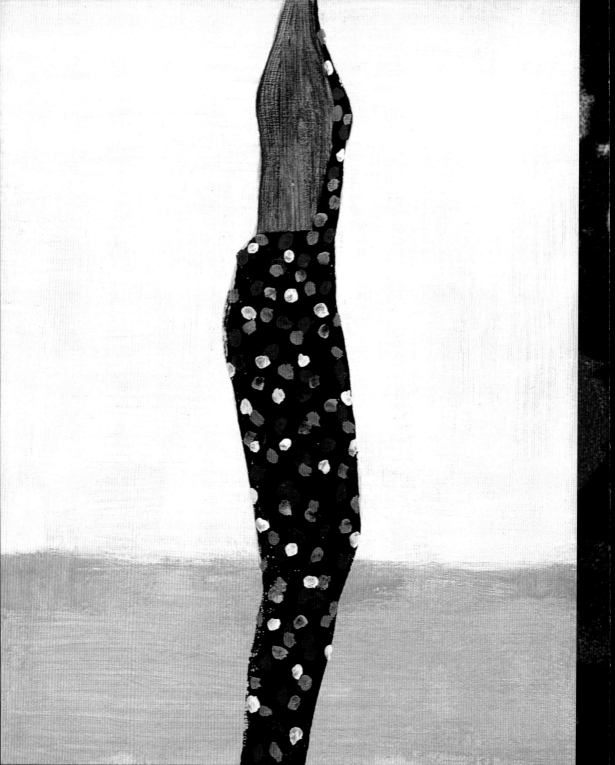

And even if

you close your eyes –

surprise! –

there's a tribal dance

of dots inside.

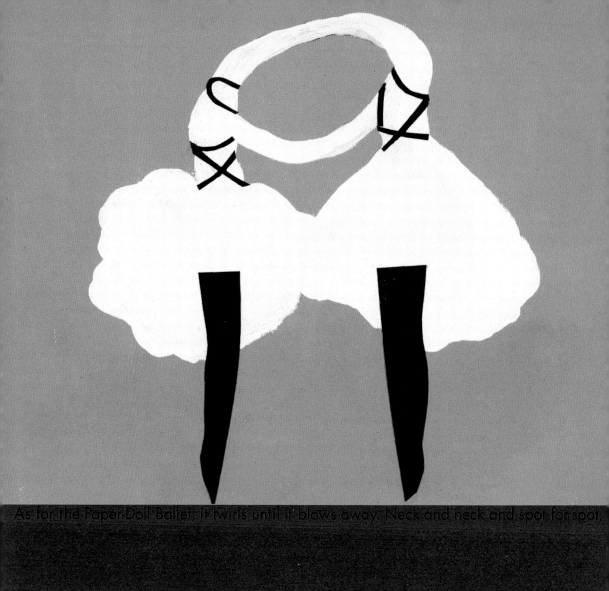

As for the Paper-Doll Ballet, it twirls until it blows away. Neck and neck and spot for spot,

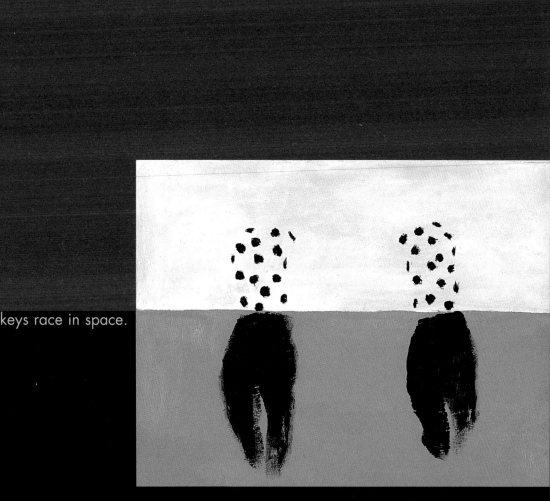

two jockeys race in space.

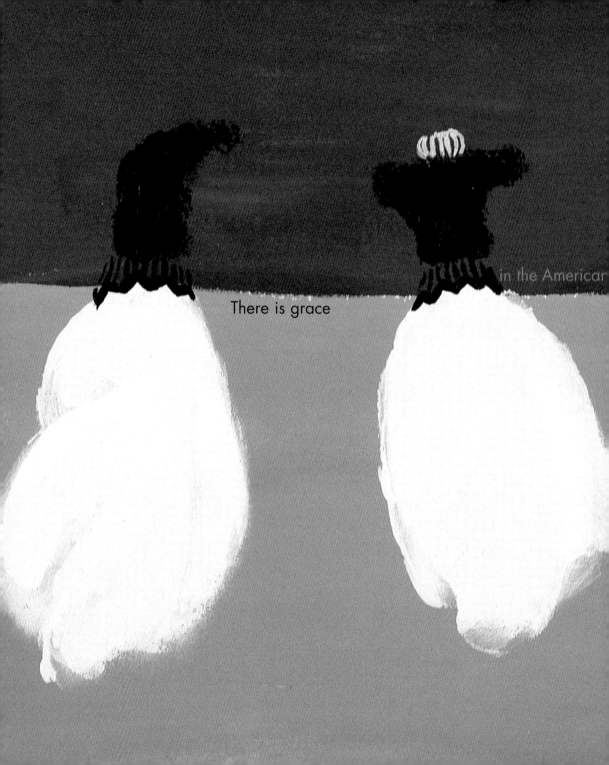

There is grace

in the American

A clean sweep.

In cities there is pavement.

Cracks and lines,

backs and spines –

they lengthen every step

(your stride becomes a glide).

On cobblestones you have

to concentrate,

but girltalk on sidewalks

is great, a kind of flight.

Just between us,

cities are where modern

goddesses live.

They sleep on skyscrapers

at night.

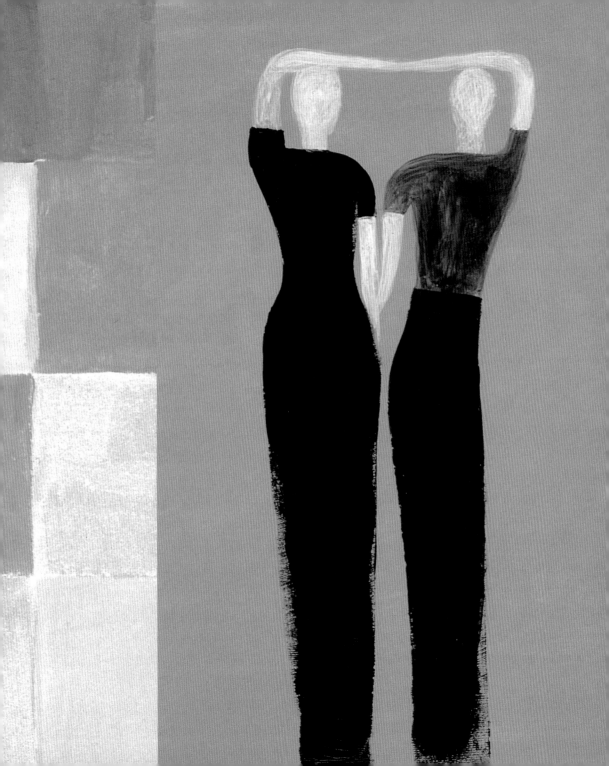

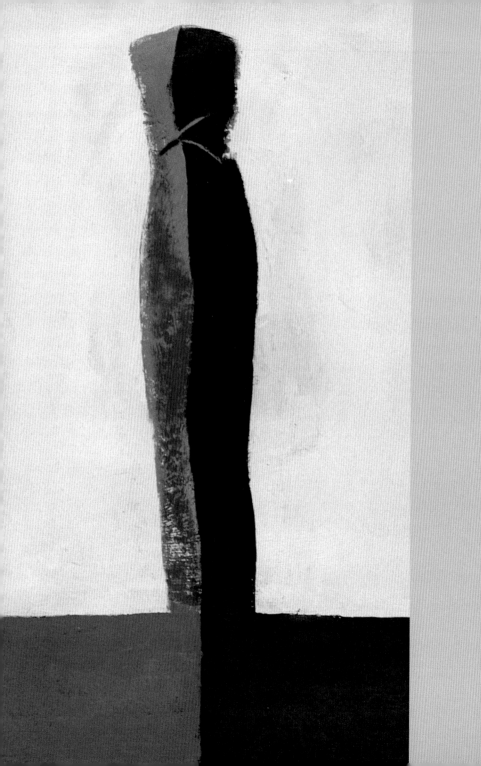

Dual forces energize the world: black and white, heavy light, up

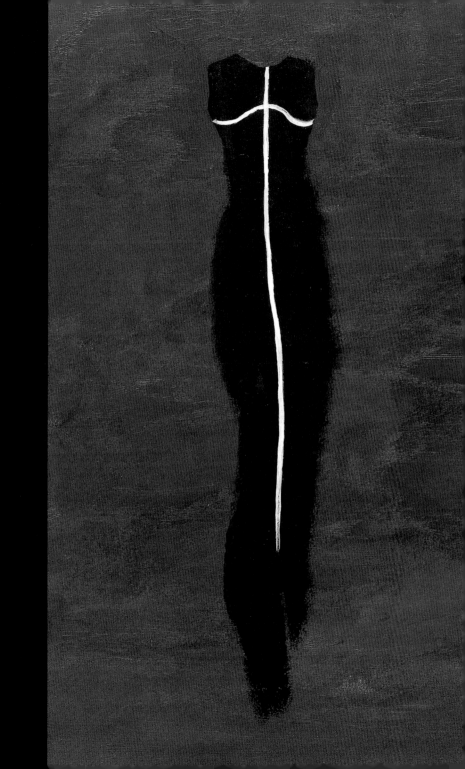

and down. The world is full of duels, too. Sword, cross, gown.

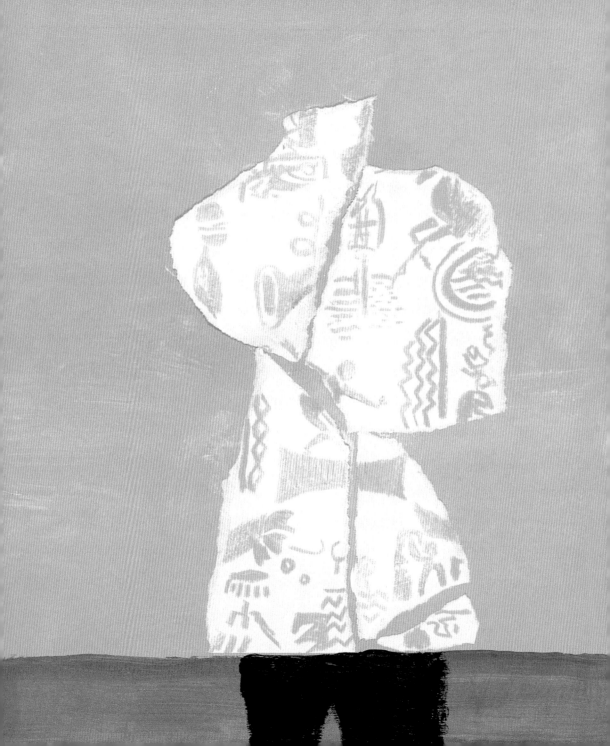

Transferwear:

a pretty porcelain with scenes

and patterns glazed right in.

A fashion plate!

What if, at 3, taking tea,

the laden table

with legs like filigree

earthquakes?

A path breaks open, a shard points the way. Did you know, triangles plane better into body crevices than any other geometric shape?

"You can cut out a triangle," says Geoffrey Beene, "and just start with it."

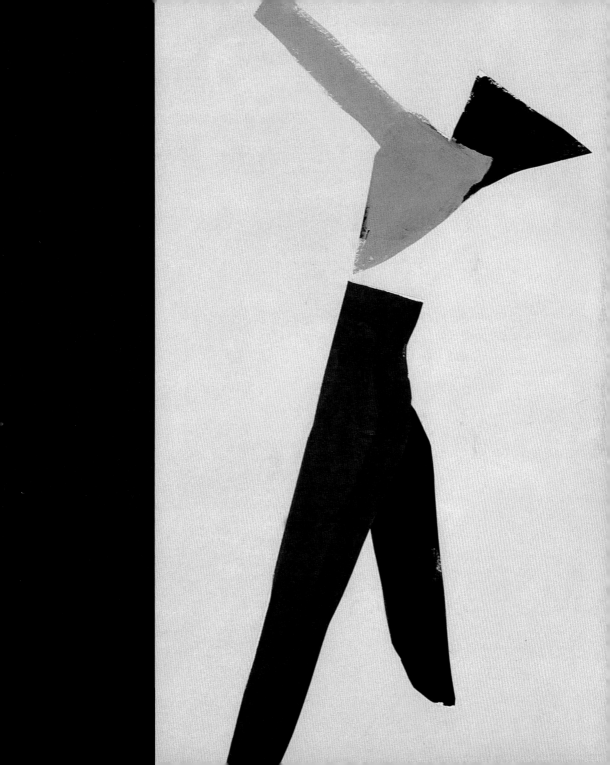

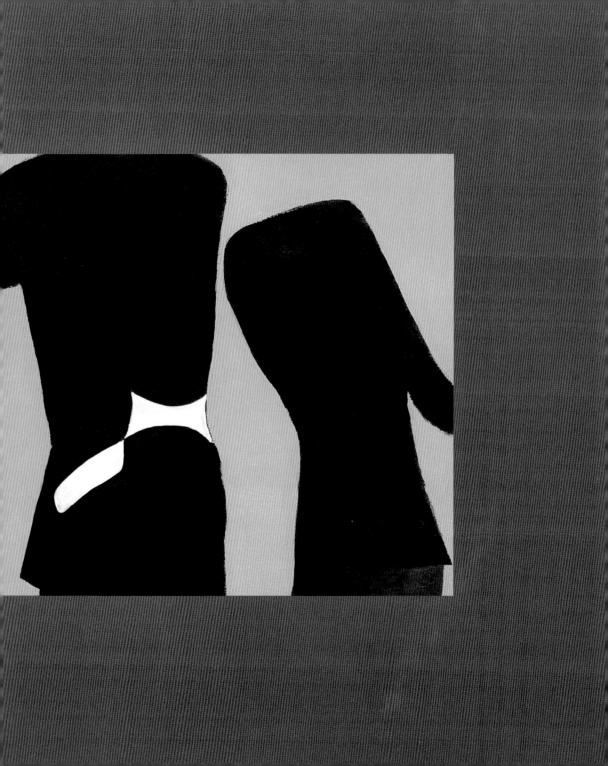

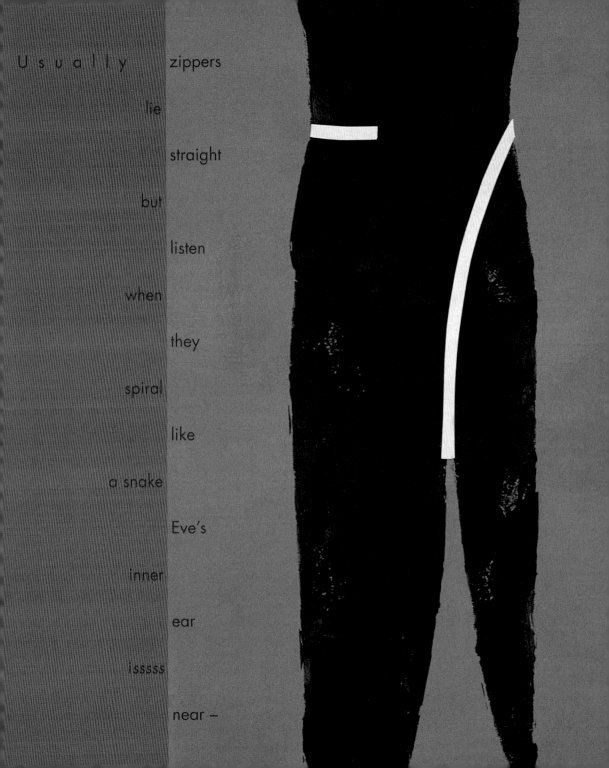

Usually zippers

lie

straight

but

listen

when

they

spiral

like

a snake

Eve's

inner

ear

isssss

near –

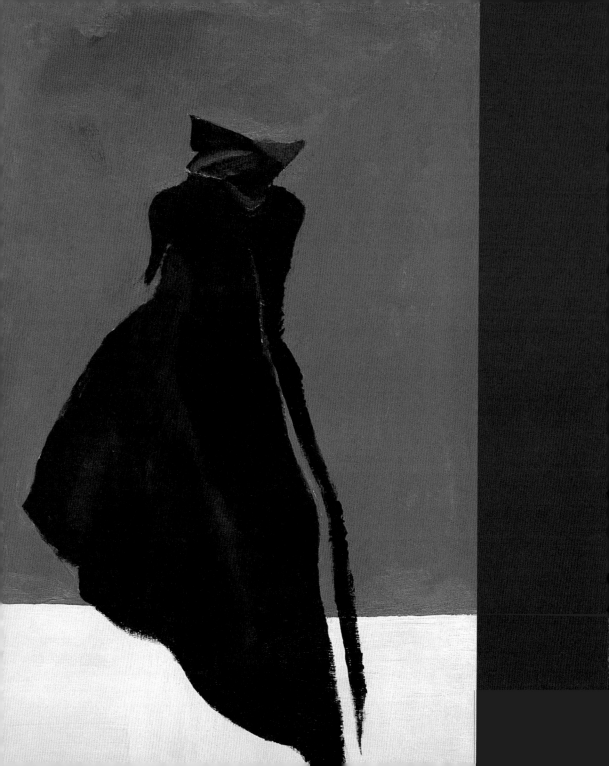

that only the moon can hear.
(the moon and the shadow are secretly engaged.)
A cape is for escapes.

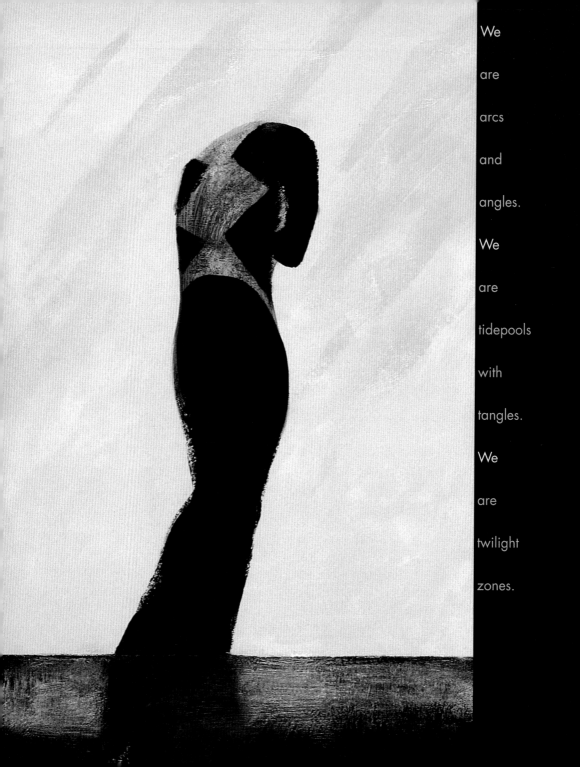

We

are

arcs

and

angles.

We

are

tidepools

with

tangles.

We

are

twilight

zones.

"To

pick

up

something

flat,

like

fabric,"

says

Geoffrey

Beene,

"and

to

give

it

human

dimension,

that

is

what

matters."

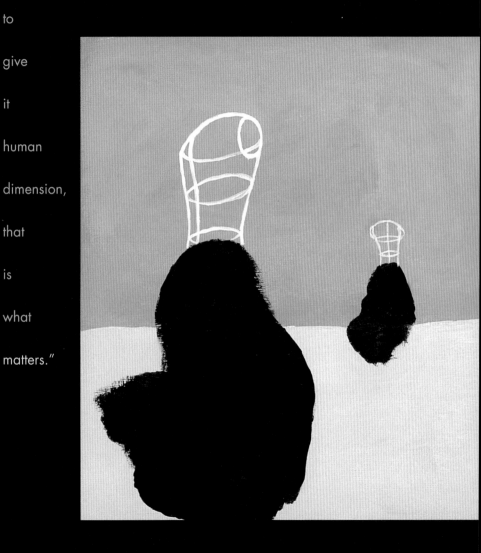

"Which of my hues," riddles The Rainbow, "is the eye most sensitive to?" "Yellow," answers Geoffrey Beene, "I use it sparingly." Except when spinning sunstorms!

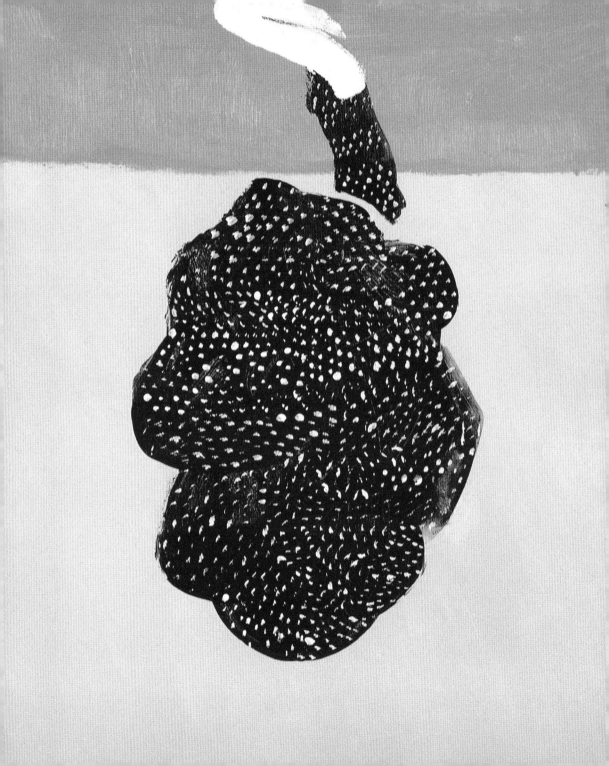

The silver sewing needle.

The Flamenco dancer's quick and thorny heel.

A pricked finger.

A red dress blossoming.

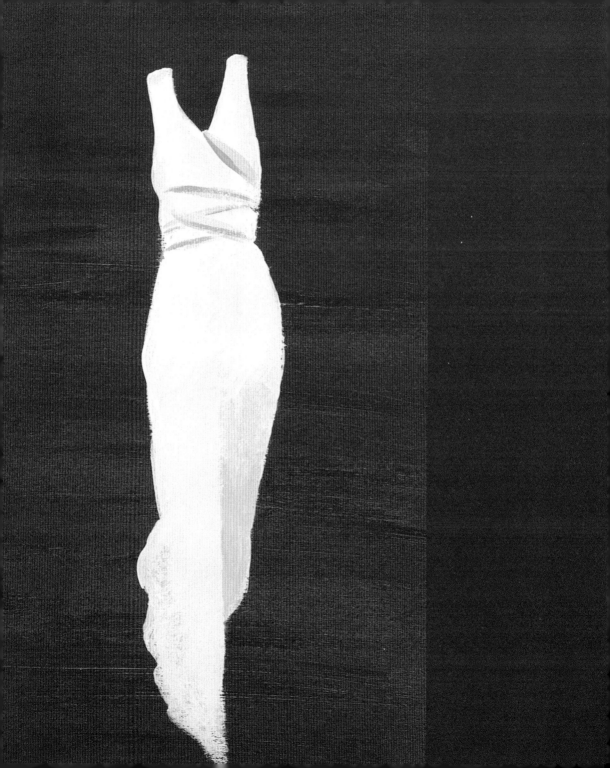

"Any black dress
changed to white,"
says Geoffrey Beene,
" goes from seductive to
innocent, sinner to saint."

Science calls an object "white"
when it reflects the light
of all visible wavelengths.
To catch the unicorn,
a woman must wear white.

Let's call proportion "X." Y? Because X means unknown (a bit like Madame X), and must be X-act and not what you X-pect.

"Proportions are very, very important. There's no rule. It's experimentation, trial and error – I do it instinctively, by eye."

Behold a dress so clean, clear, stark, severe, it stands like a commandment – a tablet from

Thou shalt not take Simplicity in vain. Thou shalt not be round (side seams were never written in stone).

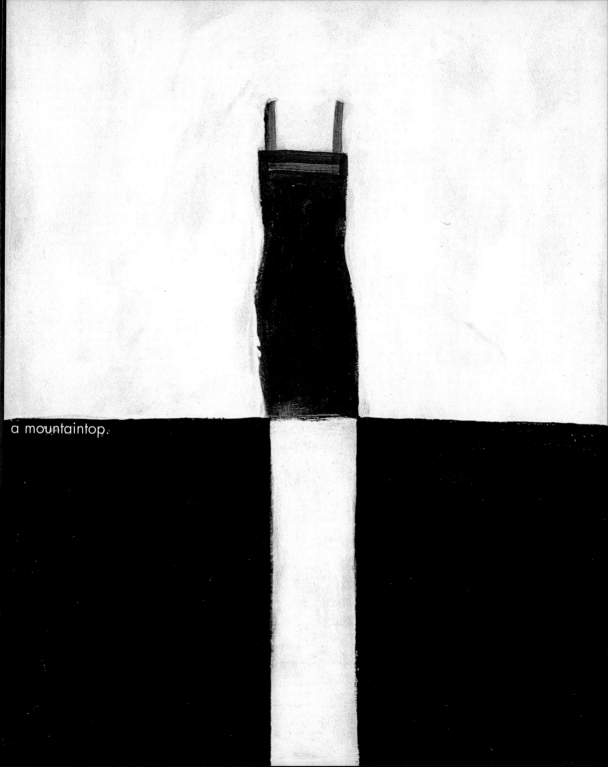

a mountaintop.

"I wanted to try a rectangle on the body."

is imposed, it always seems to

Like buildings, dresses *address* the landscape underneath, not knowing who's inside.

come in here, near the bust."

To apply right angles to the body's curves, it takes an architect. "If you look at my work, you'll see that if something

the rectangle is a door.

A door to the heart.

Beene offers us a key to this mystery:

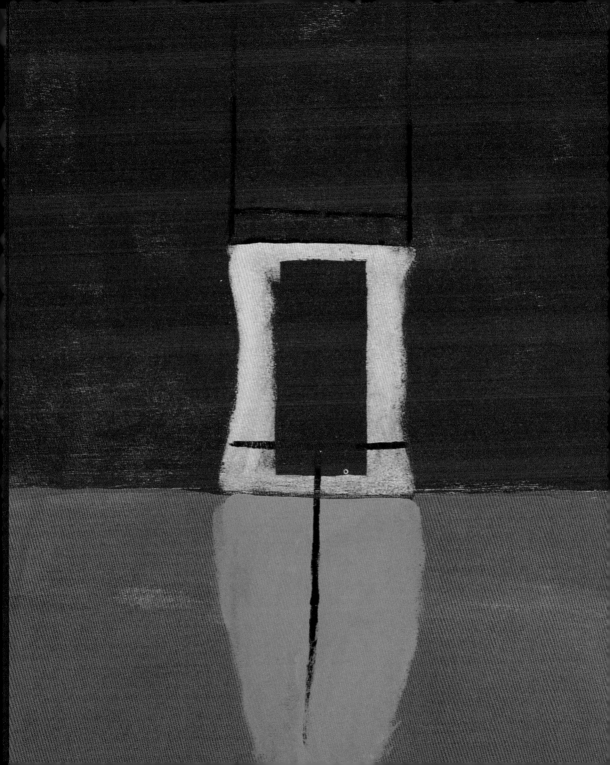

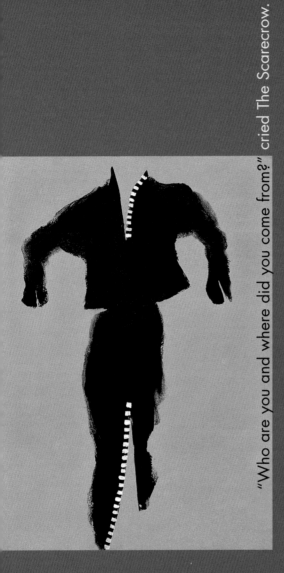

"Who are you and where did you come from?" cried The Scarecrow.

"Where did *YOU* come from?"

(It was Geoffrey Beene just having fun!)

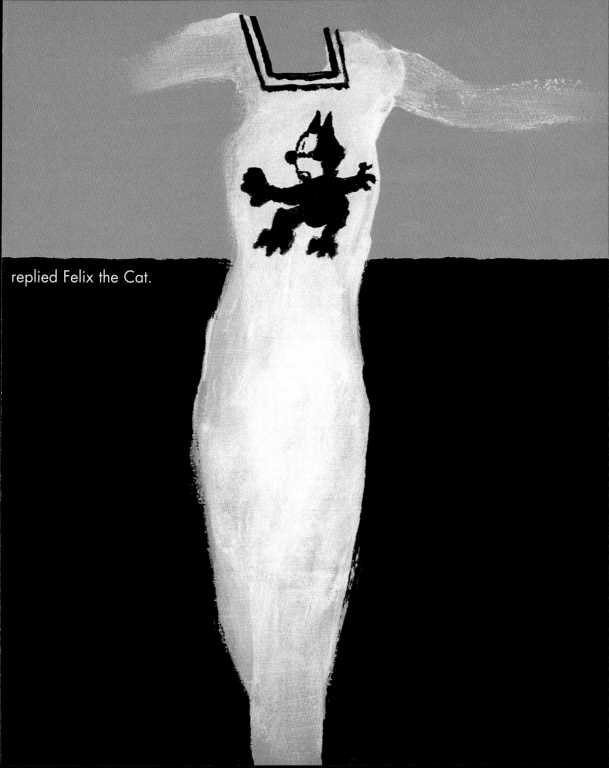

replied Felix the Cat.

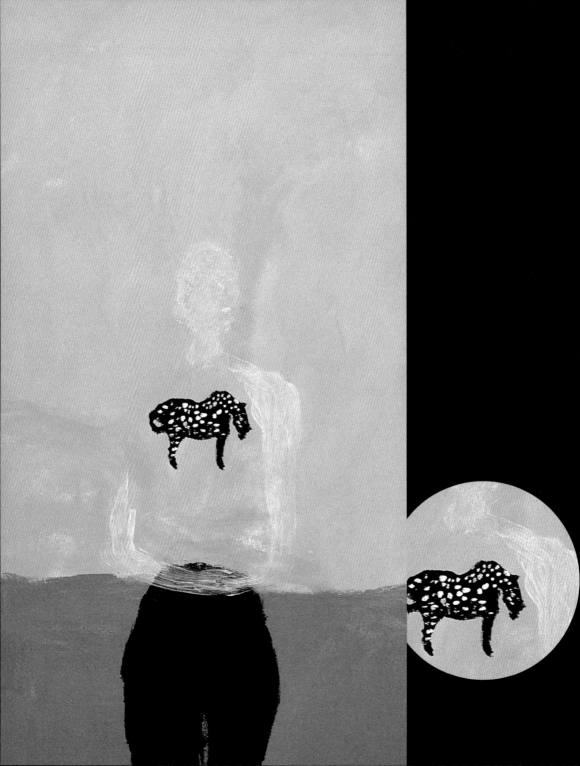

O to float on a polka-dot steed

into an untouched century (2000!).

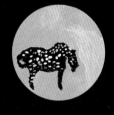

Dreams will be packed in bubble wrap,

for safe keeping.

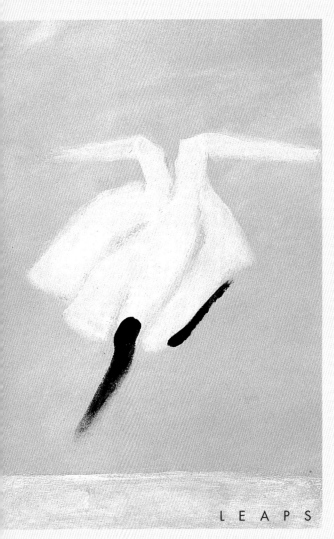

L E A P S

of faith.

Mirages

on the path.

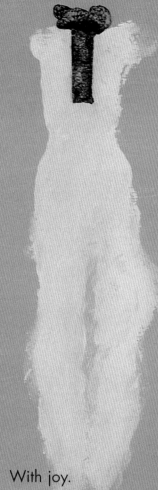

diaphanous

We are all With joy.

at times.

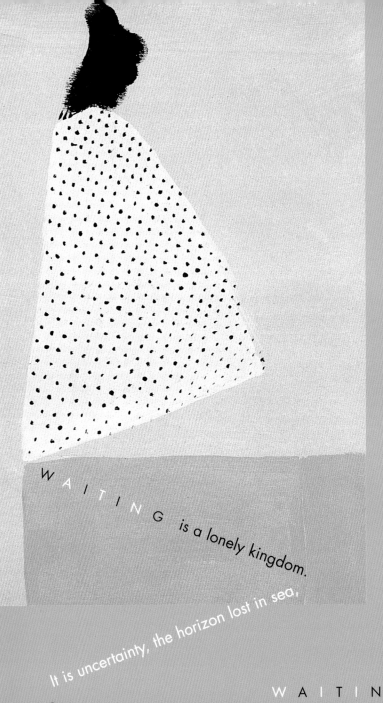

WAITING is a lonely kingdom.

It is uncertainty, the horizon lost in sea,

or is it sky?

WAITING anchors you in air.

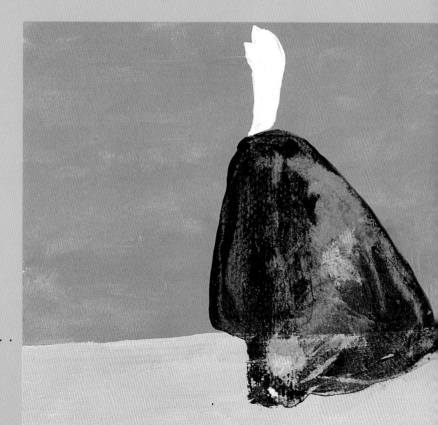

Life is full of waiting . . .

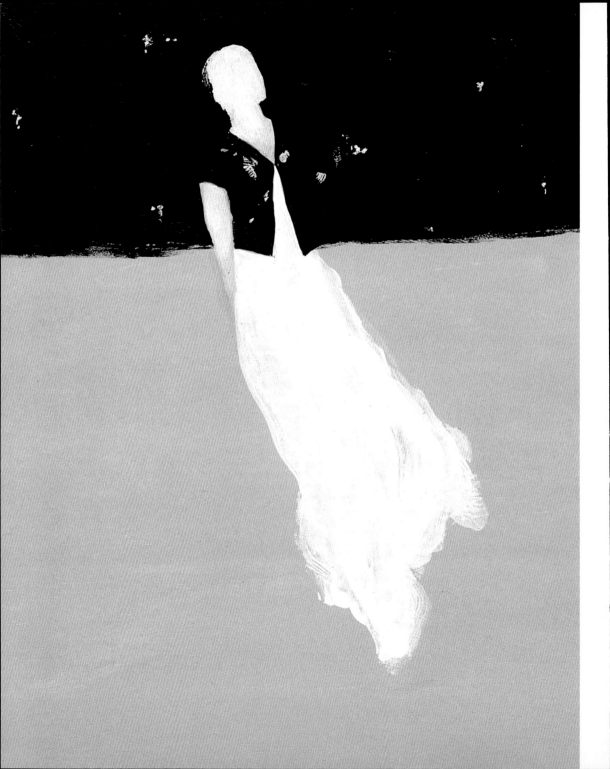

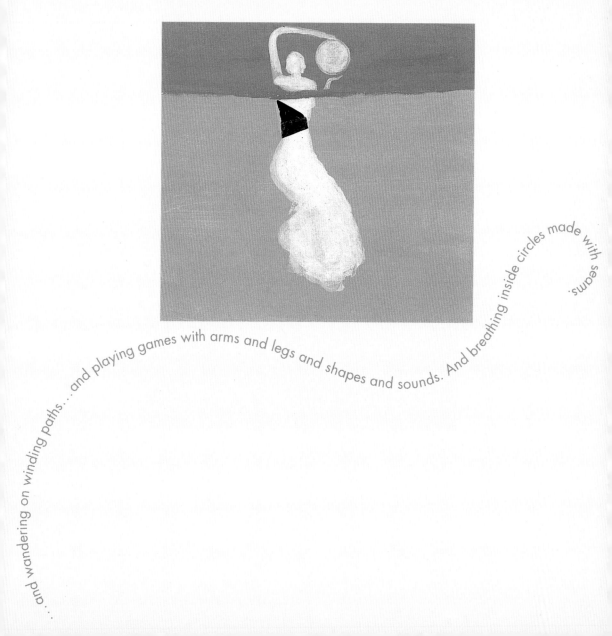

...and wandering on winding paths... and playing games with arms and legs and shapes and sounds. And breathing inside circles made with seams.

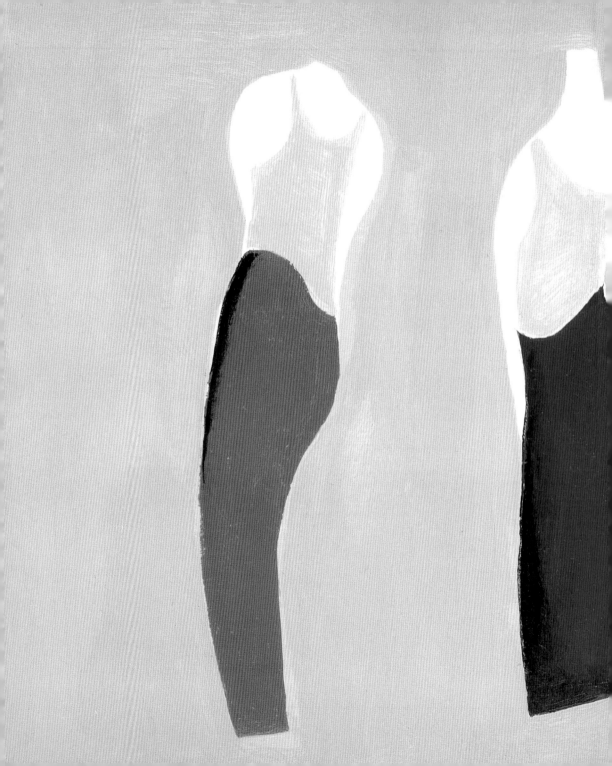